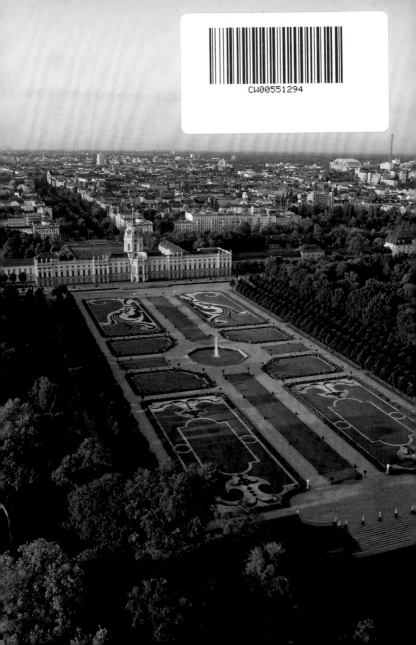

Charlottenburg Palace is the largest and most notable former residence of the Hohenzollern dynasty in Berlin. Significantly damaged during the Second World War, the site has since been largely restored to its original state. In contrast with the reconstructed Berlin Palace, transformed into the Humboldt Forum, Prussian court art and way of life are, in fact, authentically presented here. With 360,000 international visitors annually, this museum-palace is a popular destination for excursions and a desirable venue for events and exhibitions. The sprawling architectural monument with its historic garden has been shaped by the residence's seven generations of sovereigns, the operation of state administrative offices, heavy war damage and protracted, complicated phases of reconstruction. More than any other ensemble, the magnificent interiors, the masterpieces of art history and the diverse garden landscapes offer an exemplary glimpse into 300 years of history and culture of the Brandenburg-Prussian court from the end of the seventeenth into the early twentieth century.

Page 1:
View of the palace complex and garden parterre, reconstructed according to Baroque shapes and forms between 1952 and 1968

Charlottenburg Palace – History and Significance

The building that makes up the nucleus building of Charlottenburg Palace, the small pleasure palace of Lietzenburg, was built between 1695 and 1699, not far from the village of Lietzow, approximately one Prussian mile (c. 7.5 km) west of Berlin's city centre. The electress Sophie Charlotte of Brandenburg (1668–1705), second wife of the elector Friedrich III – from 1701, King Friedrich I in Prussia (1657–1713) – was in charge of its creation. The modest summer residence, designed by Johann Arnold Nering in emulation of Dutch models, was in keeping with her desire for a private retreat. The magnificent French-styled garden,

2

on the other hand, which was simultaneously created north of the building, was supposed to satisfy the demands of courtly display. Surrounded by important scholars, musicians and artists, the talented and well educated princess of the aristocratic House of Welf

C. Reichmann, View of the court-yard façade of Schloss Lietzenburg, c. 1699

in Lietzenburg, a dynasty of high-ranking nobility, succeeded in creating the first seat in Brandenburg-Prussia where a muse held sway. Together with her teacher, the multi-talented genius, Gottfried Wilhelm Leibniz, she facilitated the founding of the Berlin Academy of Sciences in 1700 by Elector Friedrich III.

Befitting its subordinate status as garden palace, court life in Lietzenburg followed a more relaxed etiquette. The daily schedule revolved around philosophy and music, garden parties, so-called peasant weddings or celebrations, evening soirees, Italian opera performances, ballets and fireworks.

After Sophie Charlotte rose in rank to become Queen of Prussia, the little summer palace, however, was no longer adequately prestigious for the state functions it would now perform. Substantial

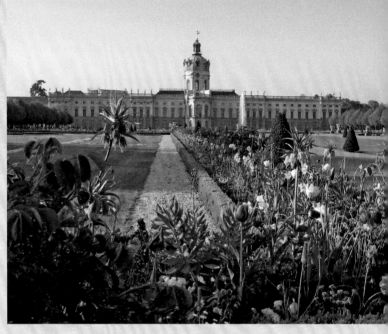

expansions of the building culminated in the three-winged Baroque complex of the Swedish architect, Johann Friedrich Eosander. In 1701/1702, imitating French prototypes, the original building was extended eastwards and westwards and furnished with an impressive 139 m long façade. After the premature death of the "Philosopher Queen" in 1705, Friedrich I ordered the palace renamed "Charlottenburg" in her honour. He had the complex – at that time still unfinished – of his preferred official summer residence magnificently expanded for himself and his third wife, Sophie Luise of Mecklenburg-Schwerin (1685–1735). The small town at the foot of the palace was elevated to the status of a city and also given the name Charlottenburg. From 1712 onwards, the

Garden façade of the Old Palace and the Baroque garden parterre with spring plantings

4

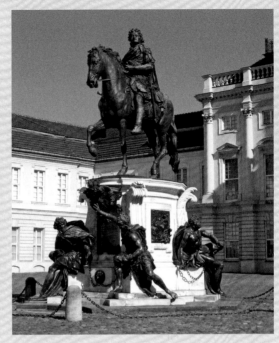

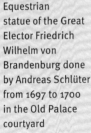

Equestrian statue of the Great Elector Friedrich Wilhelm von Brandenburg done by Andreas Schlüter from 1697 to 1700 in the Old Palace courtyard

Old Palace, forming the nucleus of the complex, was dominated by a 45 meter high domed tower with a cupola crowned by a gilded Fortuna, goddess of fortune, functioning as a weather vane.

The cour d'honneur, the monumental forecourt, was enclosed by the Kitchen Wing to the west and the Gentlemen's Wing to the east, sentry boxes and a gilded fence with the stars of the Order of the Black Eagle, the highest order of the Prussian House of Hohenzollern. Andreas Schlüter's equestrian statue of the "Great Elector", Friedrich Wilhelm of Brandenburg (1620–1688), Friedrich I's father, originally situated on the Lange Brücke (Long Bridge) by the Berlin City Palace, and then relocated during the Second World War, was placed here in 1951. Originally, there were

5

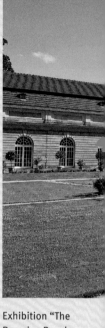

to be two orangeries for the overwintering of the valuable citrus plants that – with a total of 360 potted plants in 1744 – made up one of the most comprehensive collections in Prussia. However, only the western greenhouse was completed, bordering on the Old Palace. Destroyed in the Second World War, the exterior was reconstructed largely according to the original design. The **Great Orangery** today is a desirable location for events and is rented out for diverse cultural occasions.

In 1713, after the death of Friedrich I, his frugal son Friedrich Wilhelm I, the "Soldier-King" (1688–1740), reduced the expensive, ostentatious court display at Charlottenburg. All building activities were terminated, the ceiling paintings and interior decorations

Exhibition "The Prussian Royal House", Antoine Pesne, King Friedrich I in Prussia, c. 1710

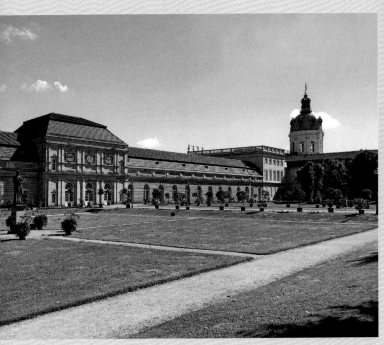

View across the orange garden to the Great Orangery and the palace cupola tower

that had been planned were no longer executed, but necessary maintenance work was still carried out. Nevertheless, the monarch made use of the palace for receptions of high dignitaries of state and for family celebrations. The garden went to seed and only the Charlottenburg kitchen garden was kept up, in order to supply ingredients for the royal table.

Upon his accession to the throne in 1740, Friedrich Wilhelm I's son, Friedrich II, better known as Frederick the Great (1712–1786), immediately started making occasional use of the palace as a residence. In 1743, he had the **New Wing** added to the eastern side of the Old Palace, according to the design of the architect Georg Wenzeslaus von Knobelsdorff. The new addition was 153 m long, two stories high, and had a

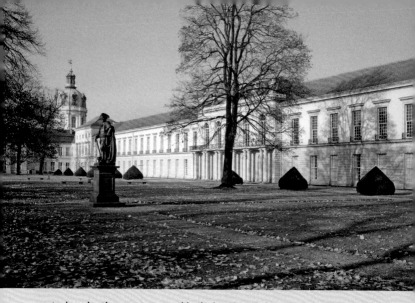

central projection accentuated by balconies and pairs of double pillars and crowned with vases. In addition to magnificent ballrooms like the White Hall and the Golden Gallery, the First and Second Apartments of Frederick the Great were built. As in all of his gardens, he valued the presence of decorative figures. The newly designed parterre was generously endowed and the Orangery once again generously equipped. However, once the Potsdam palace, Sanssouci, was completed in 1747, the king only visited Charlottenburg sporadically on the occasion of large family celebrations.

The last changes that were made to this building ensemble took place from 1788 to 1791, commissioned by Frederick II's nephew and successor, King Friedrich Wilhelm II (1744–1797). During this time, the western orangery wing was extended by the erection of the **Palace Theatre**, designed by Carl Gotthard Langhans. From 1960 to 2009, the building which had been destroyed during the Second World War and the exterior of which was faithfully reconstructed accord-

Frederik the Great's New Wing, viewed from the city side with a 1977 bronze copy of a statue of the King created by Johann Gottfried Schadow for the city of Stettin

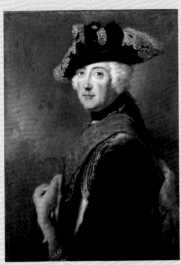 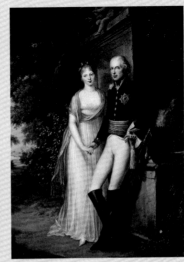

Antoine Pesne,
Friedrich II,
Frederick the Great
of Prussia, c. 1745
(*left*)

Friedrich Georg
Weitsch, Friedrich
Wilhelm II and
Queen Luise in the
Charlottenburg
Palace Garden, 1799
(*right*)

ing to the original design, served as a museum of pre-history and early history.

In 1788, the monarch had a Chinese-Etruscan style summer apartment built for himself in the New Wing which was facing the garden; in 1796/1797, the early Classical winter chambers were added on the upper floor. This series of rooms, just completed upon the death of Friedrich Wilhelm II, was regularly used by his daughter-in-law, Queen Luise (1776–1810). Her husband, Friedrich Wilhelm III (1770–1840), moved into the rooms of the western ground floor, lying directly beneath hers, which at one time had belonged to the apartments of Elisabeth Christine (1715–1797), the consort of Frederick the Great. The family life of the young ruling couple, characterized by bourgeois values, was considered to be exemplary; over the course of the years, seven children contributed to their private happiness.

From 1840, the oldest son, Friedrich Wilhelm IV (1795–1861) and his wife, Queen Elisabeth (1801–

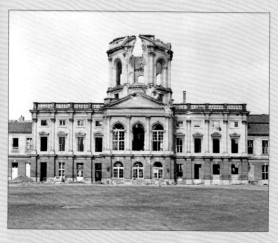

The Old Palace
destroyed by war,
1945–1949

1873), a princess from the House of Wittelsbach,
again preferred the Old Palace for its apartments on
the upper floor. During the time of the German Em-
perors (1871–1918), Charlottenburg was only briefly
used as a residence by the fatally ill Friedrich III
(1831–1888) who lived there together with his Eng-
lish wife Victoria (1840–1901). Afterwards, it served
only to receive and lodge royal guests. Subsequent
to the end of the monarchy, in 1918, and the tran-
sition of the complex to state administration, parts
of the building were made accessible as a museum
palace in 1927. Severely damaged during the Second
World War in the years 1943 to 1945, it was recon-
structed in the following decades under the leader-
ship of Margarete Kühn, and her successor, Martin
Sperlich. It was furnished with original inventory
that had been rescued, as well as with items from
the destroyed Berlin and Potsdam palaces and loans
from the House of Hohenzollern. After German reuni-
fication, through the founding of the Prussian Pal-
aces and Gardens Foundation Berlin-Brandenburg
in 1995, the surviving Prussian royal palaces in both

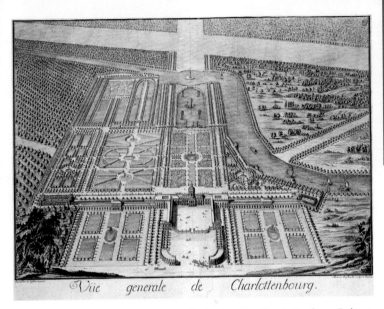

Viie generale de Charlottenbourg.

Martin Engelbrecht after Johann Friedrich Eosander, Charlottenburg Palace and Garden from above, c. 1717

East and West, including the Charlottenburg Palace, were once again brought together under one administration.

The ambitious **Palace Garden**, originally extending over more than 55 hectares (ca. 140 acres), was commissioned by electress Sophie Charlotte at the same time as the palace. Laid out from 1697 onwards, following the design of Siméon Godeau, student of the eminent French landscape architect, André Le Nôtre, it was the earliest example of this style of Baroque landscape in all of Germany. From the central hall of the palace, sight lines lead into the landscape and beyond to distant holdings such as the Spandau Citadel and Schönhausen Palace. On the waterways, the ruling family could travel in their pleasure boats from the Berlin City Palace to Charlottenburg, for the purpose of making use of the garden for splendid courtly celebrations incorporating music, dance and fire-

11

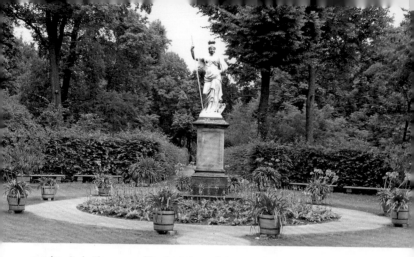

works. As in the case of its French models, the garden was laid out on different levels, thus staging as effectively as possible a gradually ascending approach from the harbour basin to the palace. Sculptures, vases and potted plants ornamented the terrace at the front of the garden. To the east and the west, the terrace was bordered by bosquets, formations of greenery which created exclusive spaces for congregation and conviviality. The eight-bed broderie parterre was symmetrically decorated with ornaments of boxwood and coloured gravel, framed with alternating strips of decorative flowers and richly endowed with gilt lead figures, latticework obelisks and cast iron vases. The focal point of the parterre was to be a fountain, a plan which could not be materialized until 1968, however. The parterre was flanked by a double-rowed avenue of linden trees, which also bordered the adjoining carp pond to the north, connected to the Spree. Flanking the parterre were the so-called bosquets, geometrically planted and trimmed hedge formations, as well as separate sections on different levels for courtly games. Until Frederick the Great's demise in 1786, the Baroque complex was cared for

Minerva, the Roman goddess of war and wisdom, a copy of Bartholomäus Eggers' original statue, dominates the southern expanse of the western bosquet

The historical pelargoniums in a "blooming exhibit"

and adapted to the needs of the times, but never really fundamentally changed.

During the reign of Friedrich Wilhelm II and his successor, the Palace Garden was gradually redesigned by Johann August Eyserbeck, Georg Steiner und Peter Joseph Lenné and by 1833 it corresponded to the English landscaping style. Parts of the Baroque avenue design were preserved; the parterre was converted into a broad meadow planted with aesthetically pleasing groves of trees. Meandering paths led to sentimental decorative figures, buildings or expressively composed garden enclosures. The banks of the canals and carp pond were designed to imitate nature closely, and intimate waterways were created around islands that were only reachable by cable ferries or bridges. In memory of the playgrounds of his childhood, Friedrich Wilhelm IV had parts of the Palace Garden reconstructed in their original Baroque form. In the course of the nineteenth century, as a result of the expansion of the city, the points of reference in the landscape disappeared. For the most part, the English-style landscape was retained, through the end of the monarchy and the heavy destruction in the

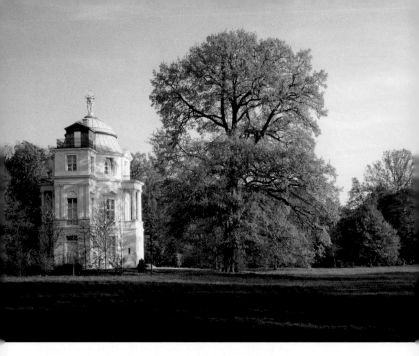

Second World War, until the period from 1952 to 1968 when the garden was redone completely under the direction of the Charlottenburg district Department of Parks. Inspired by Baroque plans, the parterre was newly designed with an octagonal fountain basin and the bosquets flanking it were replanted with hornbeam hedges. Upon the takeover of the site by the Prussian Palaces and Gardens Foundation Berlin-Brandenburg, the parterre was restored and enriched with numerous cast iron vases, among which are four marbled 'coronation vases'. The northern section of the garden has also been redesigned to include playgrounds and sunbathing meadows, with thought given to a high quality sojourn in the spirit of the times. In the last decade, the original design from the first half of the nineteenth century could be

The Belvedere erected in 1788 in the Palace Garden, and the High Bridge with a view of the garden side of the palace

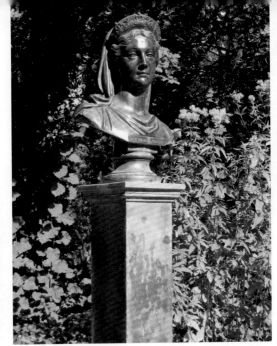

The bronze bust of Queen Luise located on Luise Island is based on the marble original of 1816 by Christian Daniel Rauch

restored in many areas. One of the most important works of historic landscape reconstruction was carried out in 1988 when the island which was created in 1799 and named after Queen Luise was rebuilt and provided with its authentic sculptural decorations. Along with copies of the Capitoline Amor and the Venus de' Medici, a bust of Luise, by Christian Daniel Rauch, ornaments the isle. Besides the seasonally changing flowers planted in the parterre, and the extensive containers of potted plants in the orange garden, the "Schloss Garden Workshop" held each April serves as an annual highlight. In the Foundation's own nursery on Fürstenbrunner Weg 62–70, the garden department offers vivid insights into its diverse activities. Especially popular is the "blooming exhibit" with more than fifty historic pelargonium

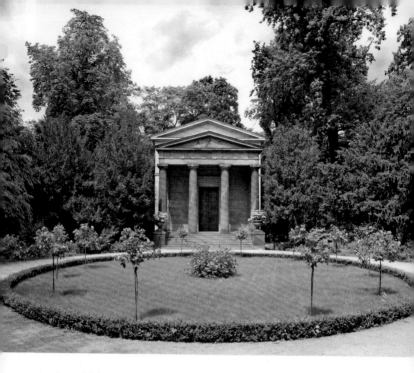

species which were set up and cultivated according to the 1804 plans of the royal gardener Steiner.

In 1788, in the secluded northern part of the garden near the Spree, the three-story Belvedere was erected on the island bearing the same name. Designed by Carl Gotthard Langhans, the building combines late Baroque and early Classical design elements. It served Friedrich Wilhelm II as a look-out pavilion and a retreat from the life at court; here was also where the mystical invocations of the spirits took place, as practiced in the secret Rosicrucian order of which the king was a member. The richly decorated interior, especially on the second floor, was destroyed in the Second World War. From 1958 to 1960, the exterior of the building was reconstructed according to the origi-

The Mauseoleum with its landscaping, which was reconstructed in 2009/2010 according to old plans from 1845

The tomb of Queen Luise, a work by Christian Daniel Rauch from 1811 to 1814, in the memorial hall of the Mausoleum

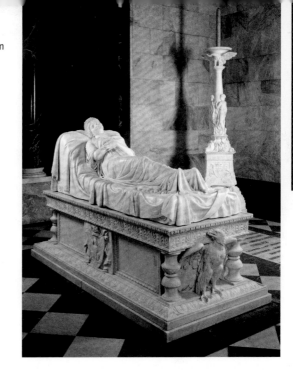

nal design; it now houses Berlin's exquisite porcelain collection, with products of the Berlin Royal Porcelain Manufactory (KPM), founded by Frederick the Great in 1763.

In 1810, after the sudden death of the beloved Queen Luise, a **Mausoleum** was erected in her honour in the western section of the palace garden at the end of a dark fir avenue. The temple-like monument was designed by Heinrich Gentz according to the wishes of Friedrich Wilhelm III. Initially, the mausoleum only contained the marble tomb of the queen, a sculptural masterpiece of the nineteenth century produced by Christian Daniel Rauch and completed in 1814. From 1841 to 1843, upon the death of Friedrich Wilhelm III, the mausoleum was enlarged according to plans by

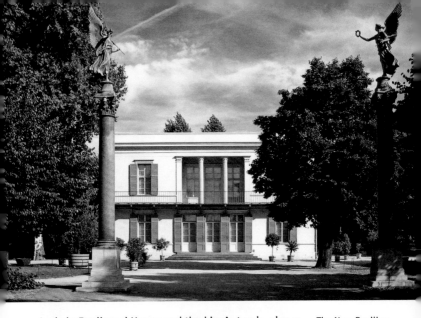

Ludwig Ferdinand Hesse and the king's tomb, also a work of Rauch's, was erected. After the death of Emperor Wilhelm I (1797–1888) and his consort Augusta (1811–1890), the building was once again enlarged from 1888 to 1894 under the direction of Albert Geyer, in order to make room for Erdmann Encke's two marble sarcophagi of the first German imperial couple. Also laid to rest in the crypt, under the memorial chamber, are Princess Auguste von Liegnitz (1800–1873) and Prince Albrecht (1809–1872) – Friedrich Wilhelm III's second wife and his youngest son – and furthermore the heart of Friedrich Wilhelm IV, who is buried in the Friedenskirche (Church of Peace) in Potsdam. The 2009 restoration of the garden layout in front of the mausoleum is based on a watercolour created around 1846 by Carl Graebs.

From 1824 to 1825, Friedrich Wilhelm III had the **New Pavilion** erected, situated to the east of the New Wing and directly on the Spree. Carl Friedrich Schin-

The New Pavilion erected according to a design by Karl Friedrich Schinkel in 1824/1825 with the granite columns and bronze victory statues by Christian Daniel Rauch in front of the building

The garden hall located on the ground floor of the New Pavilion is part of the restored royal living quarters

kel undertook the design of this two-story, practically square layout of the summer villa, modelling it after Mediterranean summer houses, including the Neapolitan Villa Reale Chiatamone in which the king had lived during his stay in Italy in 1822. The pavilion was meant to be a private retreat for the king after his marriage to the Princess von Liegnitz, who lived in the former Second Apartment of Frederick the Great in the New Wing.

The summer house, nearly destroyed in the Second World War, has been restored since 1970. It has been dedicated to the versatile work of Schinkel – as an architect, painter and designer of arts and crafts – and the Berlin artworks of his time. Alongside authentically furnished living areas, sculptures by Rauch and a collection of outstanding paintings – among them masterpieces by Caspar David Friedrich, Carl Blechen, Schinkel and Eduard Gaertner – are on display. In 2011, the landscaping around the New Pavilion has

been provided with a new interpretation in a modern style, referencing the lost design from around 1840.

As a result of considerable destruction in the Second World War and a long and complicated rebuilding process, the palace rooms display exquisite reconstructions, next to original furnishings, and museum-designed exhibition areas are on display. Many works of art come from no longer existing Prussian castles, such as the Berlin Palace, the former Hohenzollern Museum Monbijou Palace and the Potsdam City Palace or were acquired as adequate replacements from the art trade. As a result of reunification, the post-1945 independent castles administrations in Berlin and Potsdam have since 1995 returned much original equipment.

The Old Palace – Ground Floor

In the entrance room (Room 137) on the forecourt side of the building, a short film provides information about the building history of Charlottenburg's palaces and gardens.

In the **Mecklenburg Apartment** (Rooms 132, 133, 136), named after the grand-ducal relations of the House of Hohenzollern, the antique goddesses, Venus, Diana and Flora, dominate the richly endowed original ceiling painting. Whereas the overdoor reliefs, the parquet floor, the fireplace decorations and the oak panelling of this three-room guest-apartment have for the most part been preserved in their original state, the cloth wall-coverings and window curtains have been renewed, as in almost all of the rooms in the palace.

Numerous paintings, including portraits of the Brandenburg-Prussian royal family illustrate the Berlin court and the reign of Elector Friedrich III. Up-

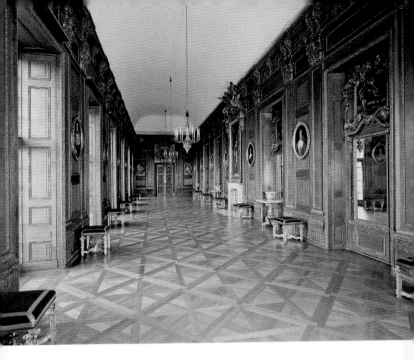

Old Palace,
Friedrich I's
staterooms,
Old Gallery

on his self-coronation in East Prussian Königsberg in
1701, he named himself King Friedrich I in Prussia.

*From Room 133, the tour continues on the garden side
through the staterooms and private apartments of
Friedrich I and Sophie Charlotte.*

In Charlottenburg, the representative apartments
of the royal couple are located on the ground floor,
based on the plan existing when Sophie Charlotte
resided in the palace, which already offered direct
access from the rooms into the garden. The audience
hall of the queen (Room 119), dominated by large-
scale official portraits has been almost completely
repanelled with oak. Adjacent to Friedrich I and
Sophie Charlotte is a portrait of Friedrich's succes-

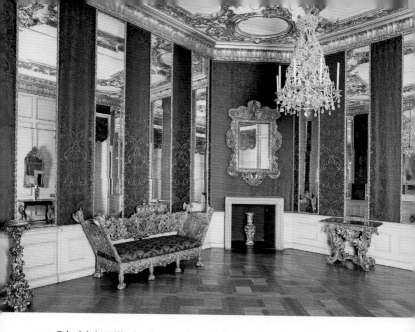

sor, Friedrich Wilhelm I, together with his consort, Sophie Dorothea, painted by Antoine Pesne and his workshop. The "Meeting of the Three Kings," which took place in 1709 during the Great Northern War, between Friedrich I, Friedrich IV of Denmark and the elector of Saxony, August the Strong, as King of Poland, was documented by Samuel Theodor Gericke in an "alliance portrait" of the three monarchs. The gilded console table is from the Berlin City Palace. The carving of the restored, for the most part still original oak-panelled walls of the **Old Gallery** (Room 120) is most probably the work of the Englishman, Charles King. It provides a decorative framework for the loosely chronological series of ancestral portraits of members of the House of Hohenzollern from the first Brandenburgian elector, Friedrich I, to Frederick the Great and his consort Elisabeth Christine. Displayed above the fireplace is the full-length

Old Palace, First Apartment of Sophie Charlotte, Glass Bedchamber

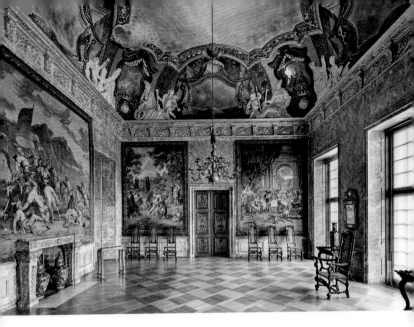

Old palace,
Staterooms of
Friedrich I,
Audience Chamber

portrait of Friedrich I, painted by Friedrich Wilhelm Weidemann. Four pedestal tables, a neo-Baroque footstool from the Berlin City Palace, and four bronze chandeliers dating from about 1900, complete the furnishing.

The tour continues in Room 118.

The rooms in the nucleus of the palace, rebuilt to approximate the original, belonged to the **First Apartment of Sophie Charlotte** (Rooms 102, 103, 116–118). The reconstructed gilded stucco ceilings, without the original paintings, display the late Baroque sculptural ornamentation style of the period preceding 1700.

According to an inventory compiled after the death of the Queen in 1705, her rooms were decorated with multi-coloured damask and brocade wall-coverings.

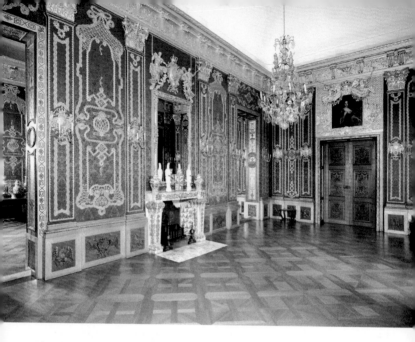

The abundant porcelain and the exotic, lacquered furniture are in the Chinese style so popular at the time. Today, the reconstructed walls of the Glass Bedchamber (Room 118) are again decorated with narrow bands of green damask alternating with similar widths of mirrored surface. Differently from the time of Sophie Charlotte, however, the Green Antechamber (Room 117) and the two rooms to the west of the Oval Hall (Room 116) showcase large-scale tapestries from the Huguenot Charles Vigne's Berlin manufactory produced around 1740/1750.

The centrally located Oval Hall, the five French doors of which project into the garden, was reconstructed with substantial changes. In 1705, there were 85 paintings hanging here, many of them royal portraits. Today, a small number of portraits of relatives of the Prussian Imperial pair as well as of con-

Old Palace,
Staterooms of
Friedrich I,
Red Chamber

Old Palace,
Staterooms of
Friedrich I,
bedroom with
partly
reconstructed
Baroque
ceremonial bed

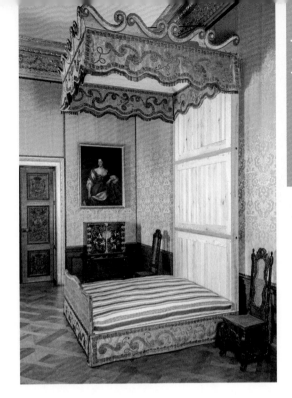

Side 26/27:
Old Palace,
Staterooms of
Friedrich I,
Porcelain Cabinet

temporary European regents, give an impression
how the original room appeared. The outfitting of
the Antechamber (Room 102) and the adjacent Audi-
ence Chamber with tapestries took place only after
the destruction of Charlottenburg during the Seven
Years' War. The wall hangings depict scenes of court-
ly social gatherings in the style of the painter Antoine
Watteau. The virtuously executed lacquer painting of
scenes of the palace in chinoiserie-style on Sophie
Charlotte's white harpsichord is a Berlin work of Gé-
rard Dagly's from about 1700. The fireplace axis in the
Audience Chamber was reconstructed according to a
photograph from 1910.

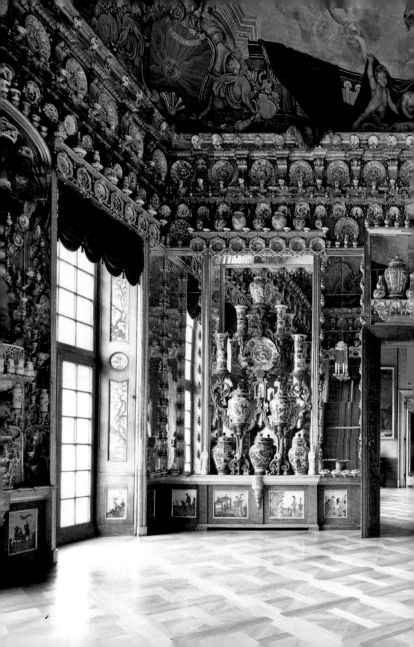

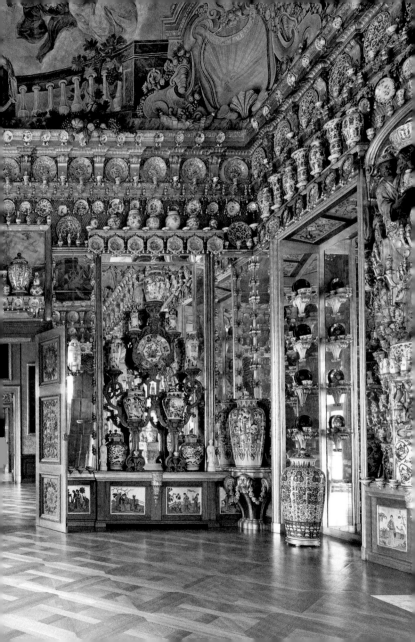

The **Staterooms of King Friedrich I** (Rooms 101, 100, 99, 96), are situated again in what is Eosander's extension building. Moving from the anterooms to the highest-ranking rooms, from the Audience Room through the bedroom to the Porcelain Cabinet and finally, to the Chapel, the sumptuous and precious interior decoration of textiles and furniture progressively proliferates. Next are the rooms of the Second Apartment of Sophie Charlotte, which were used by the king only after the death of his consort and featured furnishings and decoration that is less for display and more to private taste. The present furnishings of the staterooms is based largely on information from a 1770/1780 inventory, which also allows conclusions regarding the baroque interior of the early 18th century.

In the Audience Chamber (Room 101), the reconstructed ceiling shows embodiments of the Arts and the Sciences. The valuable Brussels Gobelins made in 1712, depict scenes from the lives of famous heroes of antiquity, while the seating furniture and bean game refer to the different functions of the room. During public audiences, the monarch received other princes, diplomats and ambassadors standing; in the evening, the court society socialized to musical accompaniment and at the gaming tables. It was only during these more casual amusements that the entire flight of staterooms was visible.

The reconstructed wall decoration of the Red Chamber (Room 100), which has a gallery-like character and possibly served as a conference room, was made with red damask and gold braid trim. The overdoor portraits depict Friedrich I and Sophie Charlotte.

In the five-part original ceiling painting in the adjoining Cabinet (Room 99), the signs of the zodiac and the allegories of the four seasons can be seen. The presence of two audience chairs suggests that the king used this study for smaller private audiences.

The Bedchamber (Room 96), with its reconstructed yellow silk-damask wall covering, is dominated by the partly preserved, Baroque ceremonial bed. The ruler never slept there; like the precious East-Asian lacquer cabinet cupboards it had only a representational function and at most was made available to visitors of the same rank or to princely bridal couples during the marriage ceremonial. The wind dial over the mirror, connected to a weather vane, displays not only the direction of the wind but also refers to the contemporary interest in astounding scientific discoveries. A concealed door leads to a narrow servant's passageway and six steps down into a marble-floored, oak-panelled bathroom (Room 98), which, contrary to the ceremonial bed, was also used.

The final culmination of the official rooms of Friedrich I is the Porcelain Cabinet (Room 95), which is for the most part reconstructed and is overarched by a ceiling painting with the cosmological theme, Aurora, the Dawn Casting Out the Darkness, painted by Anthonie de Coxie in 1706. The gold-framed mirrored walls multiply the more than 2,600 works of porcelain, mostly from the Chinese K'anghsi period (1662–1722), that are arranged architectonically and symmetrically around the room. Conceived as a glorification of Friedrich I's newly created Prussian kingdom, the Charlottenburg Porcelain Cabinet is the largest and most important of its kind in all of Europe's palaces and an outstanding example of the Baroque enthusiasm for China.

The reconstructed Chapel (Room 94) is articulated by a system of pillars with gilt stucco ornamentation and wall paintings. The ceiling, decorated with scenes from the Old and New Testament in 1708 by de Coxie, has also been reconstructed. Under the oaken pulpit stands the original altar table, richly carved and gilded by King. Located on the opposite side, is the king's box, decorated with the Prussian eagle

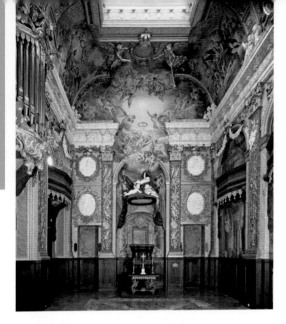

Old Palace,
Chapel, view of
the pulpit altar

and with two Famas bearing the mighty royal crown.
The Protestant-Reform denomination of the Hohen-
zollern and their notion of divine right of kings are
manifested in the spatial positioning of worldly and
spiritual power, of throne and altar. The organ in the
loft, built in 1706 by Arp Schnitger and destroyed dur-
ing the war, has been reconstructed by Karl Schuke.
The chapel was used for worship services and devo-
tions and also accommodated the weddings of the
ruling dynasty, in particular members of the family of
Frederick the Great.

*The tour continues through a modern hallway into
Room 88.*

The oak-panelled Chinese Gallery (Room 88), con-
structed around 1710, displays according to its origi-
nal function, the appropriate East Asian porcelain.

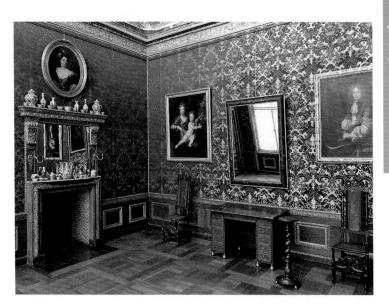

Old Palace, Second
Apartment of
Sophie Charlotte,
Chambre de Toilette

Portraits of the Italian Baroque composers who had been commissioned by Sophie Charlotte as well as a portrait of the polymath scholar Leibniz in the adjacent room – formerly used by one of Sophie Charlotte's chamber ladies (Room 107) – attest to the importance of music and philosophy at this Lietzenburg seat of the muse. The **Second Apartment of Queen Sophie** Charlotte (Rooms 109–111), completed in 1705 on the courtyard side of the palace, includes four rooms, which in 1702 were planned as a winter apartment, containing for the most part originally preserved ceiling paintings with grotesques and scrollwork after French models in the style of Jean Berain and Claude III Audran.

While in the ceiling painting of the Golden Cabinet (Room 109) the muse god, Apollo, is central, on the ceiling of the toilet chamber (Room 110) Venus is shown together with Aurora, who is scattering roses.

Family portraits and portraits of foreign or unusual personalities indicate the Queen's interest in different religious beliefs and ways of life. The lacquered furniture, manufactured in the Berlin workshops of Dagly about 1700 in imitation of East Asian models, is a reminder of the formerly rich furnishing of the apartments in "Native American" style.

On the ceiling of the bedroom (Room 111), the allegories of the night make their appearance. According to the inventory of 1705, the original décor included sixty-six, mostly Dutch, paintings of the seventeenth century, among which were landscapes, genre scenes and portraits, like Schoonjan's 1702 painting, Crown Prince Friedrich Wilhelm (I) as David with the Sling. Of the known furnishings of the Writing Cabinet (Room 112), the white, lacquered escritoire decorated with painted chinoiserie has survived.

The tour continues up the stairway to the upper floor of the Old Palace.

In Eosander's stairwell of 1704 (Room 113/208), the stucco reliefs and the railing, which were damaged in the war, have been reconstructed. The large-scale allegorical paintings of the four parts of the earth known at that time – Europe, Asia, Africa and America – were created by Augustin Terwesten in 1694 for the Berlin Palace.

The Old Palace – Upper Floor

The upper floor, decorated about 1700 as an apartment for Sophie Charlotte's son, Crown Prince Friedrich Wilhelm (I) and relatives of the royal family, was completely redesigned from 1840 onwards for King Friedrich Wilhelm IV and his consort Elisabeth of Bavaria. After these rooms were almost com-

pletely destroyed in the Second World War, the former apartment of Queen Elisabeth (Room 212–213, 216–217) has merely been restored according to its original spatial design. It now serves as a museum. The thematically designed exhibition, "The Prussian Royal House," provides an introduction to the dynasty of the Hohenzollern who originated from Swabia. Shown are characteristic aspects of their family and the history of their rule, which are manifested in the distinctive style of a Prussian military monarchy. Their careers as Nuremberg burgraves, electors of Brandenburg, Prussian kings and Germans Emperors are illustrated in important works of art such as the insignia of the Königsberg Coronation of Friedrichs I and Wilhelm Camphausen's monumental painting "Friedrich the Great on Horseback" from 1870.

In contrast with the historical presentation in the dynasty museum, the former apartment of Friedrich Wilhelm IV has been partly equipped with its original inventory and enriched with artworks from other apartments of the royal couple in Berlin and Potsdam palaces.

The 42-flame chandelier, designed by Schinkel around 1809/1810, is part of the original inventory of the Round Hall (Room 210), which was used as a dining room. The monumental vases originating from

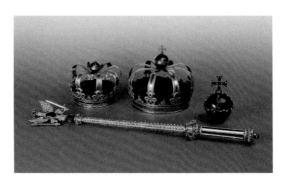

Old Palace, Dynasty Museum. The Prussian Royal Insignia from 1701

the Imperial Porcelain Manufactory in St. Petersburg were presents given by imperial relatives.

In the Dynasty Museum the tour can be interrupted for a visit to the Silver Chamber (Rooms 220, 221, 223, 224, 230, 232, 234–236).

In the **Silver Chamber**, valuable tableware made of precious metals, glassware and parts of extensive porcelain table services from the Baroque period into the early twentieth century are on view. They are displayed according to their historical significance on buffets or included as parts of staged table settings.

In times of crisis, the silverware could be melted down and made into coins which is why the Silver Chamber served both as the court's money box and cupboard cabinet. Next to individual porcelain china, which Frederick the Great, until the founding of his own manufactory, the Berlin KPM 1763, had obtained from Meissen in Saxony, the "Crown Prince Silver" from 1905 represents the glamorous culmination and end point of Prussian courtly table culture.

Returning to the Dynasty Museum, the path on the garden side leads to the Oval Hall.

The Oval Room (Room 211), with its mirrored wall surfaces opposite the window side of the room, gives the impression of being a freestanding pavilion surrounded by gardens. In accordance with the records of how it looked in the time around 1700, the ballroom was reconstructed with a richly stuccoed and gilded cornice under the shallow, arched ceiling. The Flemish pewter chandelier with 24 candleholders was made in 1647.

In the Red Room of the **Apartment of Friedrich Wilhelm IV** (Rooms 203–206) (Room 206), which was used by his adjutants, landscape paintings of South

Old Palace,
Apartment of
Friedrich Wilhelm IV,
Library

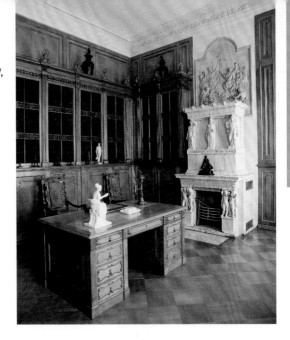

American jungle scenes by Ferdinand Bellermann are a reminder of Alexander von Humboldt's expeditions. This natural scientist was in the inner circle of the king's friends.

In his Lecture Room (Room 205) as well as in his Workroom (Room 204), paintings of Mediterranean landscapes, church interiors as well as portraits of persons who were close to him reflect the king's private world, his thoughts and inclinations. The Library (Room 203), designed by Johann Heinrich Strack and completed in 1846, still has its original furnishing; its oak-panelled walls and architectonically articulated bookcases were inspired by antiquity. The furniture, painted maple colour, the white Berlin tiled oven and decorative objects of bronze, plaster and cast iron convey an atmosphere of domestic comfort.

Friedrich the Great's New Wing can be entered via the columned entrance on the southern side of the building.

New Wing – Upper Floor

The New Wing, almost completely destroyed in World War II, has been largely restored. On the eastern side of the upper floor are the ballrooms and the Second Apartment of Frederick the Great (Room 362–367), and to the west his First Apartments (Room 346, 353, 358) and Friedrich Wilhelm II's Winter Apartments in which Queen Luise lived (Room 348–352).

The tour begins on the eastern upper floor with the ballrooms and the Second Apartment of Friedrich the Great.

The longitudinal walls of the White Hall (Room 362), used as a dining room and inaugurated in 1742, are each articulated with five round-arched windows and fluted Corinthian pilasters made of stuccolustro of light pink going to white and pale green. As a paraphrase to the destroyed ceiling painting by Pesne, the artist Hann Trier created an abstract symphony of pastel tones in 1972/1973. The 42 meters long Great or Golden Gallery (Room 363), designed by Johann August Nahl the Elder and Johann Michael Hoppenhaupt the Elder, is one of the most imaginative spatial creations of the Frederician Rococo. Reconstructed from 1961 to 1973, gilded or-namentations consisting of rocailles, blossoming tendrils, fruits and figures are spread out like a net over the green stuccolustro of the walls, the colour of which corresponds to the natural surroundings outside. Richly

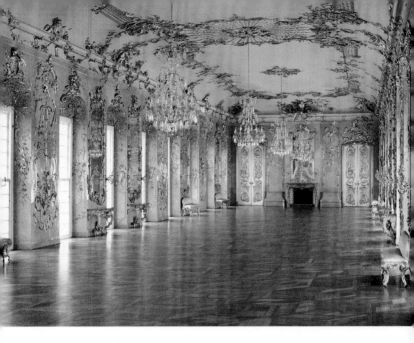

New Wing, Great
or Golden Gallery

carved gilt benches and console tables as well as antique marble busts complete the original furnishing of the garden ballroom.

Shortly after the completion of the Golden Gallery in 1746, the so-called **Second Apartment** (Rooms 364–367) was built at the eastern end of the New Wing. In the Concert Chamber (Room 364), with its white panelling and golden ornamentation, almost all paintings belong to the original inventory, including Antoine Watteau's "The Shop Sign of Gersaint," created in 1720 and acquired in 1745. Ironically shedding light on buying and selling of works of art in eighteenth century Paris, it is the most important French painting of this period to be found in the Prussian palaces.

There are further paintings, documented in the inventories, with mythological representations of an-

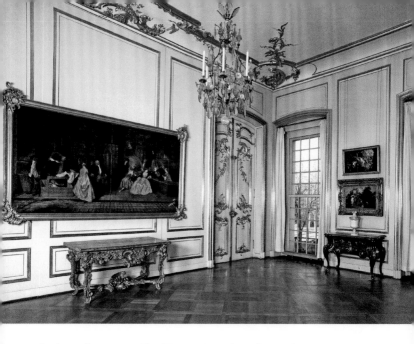

tiquity and genre motifs of famous French, Italian and Dutch artists in the Gris-de-Lin Chamber (Room 365), a room covered with pale violet damask.

Inlaid in the panelling of the adjoining Writing Room (Room 366) were formerly five eighteenth century paintings. The landscape paintings depicting scenes of social life that now serve as replacements were done by Charles Sylva Dubois, Pesne, von Knobelsdorff and Johann Harper.

During the time of Friedrich the Great, no paintings were hung in the last room of the Second Apartment, the green Bedchamber (Room 367). Besides a bed frame, the inventory of 1770/1780 merely lists a seating set, a gilded table and a night-commode.

The tour continues in Room 352.

New Wing, Second Apartment of Frederick the Great, Concert Chamber with Antoine Watteau's painting "The Shop Sign of Gersaint" from 1720

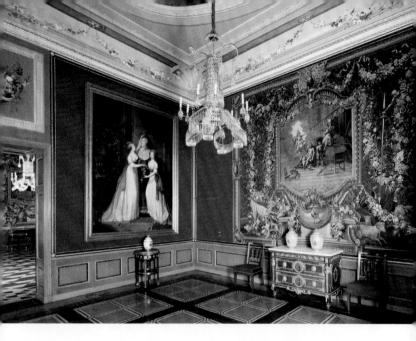

New Wing, Winter
Chambers, First
Hautelice Room

The early classical **Winter Chambers** (Rooms 348–352), furnished in 1796/1797 upon the request of Friedrich Wilhelm II, assisted by his long-standing confidante and companion, Wilhelmine Gräfin von Lichtenau, were not finished until shortly before the demise of the monarch. The series of rooms were first inhabited primarily by his daughter-in-law, Luise von Mecklenburg-Strelitz. The reconstructed rooms contain most of the original furniture, the Gobelins and chandeliers having been largely preserved.

The First Hautelice Room (Room 352) served the queen as an anteroom. The series of French Gobelins in this and the following room with scenes from the life of Don Quixote were gifts from King Louis XVI to prince Heinrich of Prussia. The imposing painting, done by Friedrich Georg Weitsch in 1795, shows the sisters Luise and Friederike crowning the bust

39

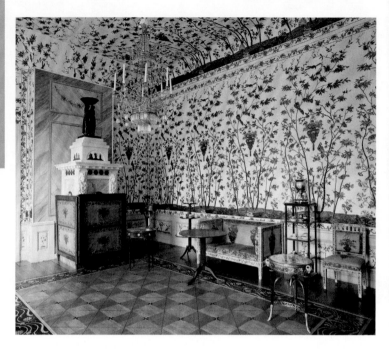

of their father-in-law, Friedrich Wilhelm II. The clay oven by the Berlin Manufactory of Johann Gottfried Höhlers, characteristic of the Winter Chambers, was reconstructed here as in the other rooms. Included in the original inventory of the Second Hautelice Room (Room 351), used as a dining room, was the mahogany seating set. The valuable chandelier, as in nearly every room, was supplied by the Berlin workshop of Werner & Mieth.

In the Bedchamber (Room 350), the walls of which are covered with yellow-and-white-striped and flowered Atlas cloth, the seating set is of maple wood, carved to simulate bamboo. The desk, with a small upper section made by David Hacker, belongs to the original furnishing.

New Wing, Winter Chambers, East Indian Chintz Room

New Wing,
Bedchamber of
Queen Luise

In the Writing Room (Room 349), Luise's simple mahogany escritoire stands in front of a wall with a Chinese silk wall covering painted with tree peonies and exotic birds.

The ceiling and the walls of the East Indian Sitting Room (Room 348), presumably used as a dressing room, have been reconstructed with a decorative wall covering of chintz. Printed with bands of birds and slender bouquets or baskets of flowers, and then waxed, this cotton fabric was meant to call forth the illusion of a garden pavilion. The set of seating furniture of 1797 is supplemented by serving tables and tables set with porcelain.

In 1810, Friedrich Wilhelm's former dressing room designed by Schinkel was redone as a new bedcham-

ber for Queen Luise (Room 347) and the walls were covered with white gathered voile over rose-coloured wallpaper. The bed and the small pear wood flower tables belonged to the original furnishings.

The following rooms, which to some extent are still in their original state, belonged to the **First Apartment of Frederick the Great** (Room 346, 353–358), constructed in 1742.

Originally, the Yellow Atlas Room (Room 346) was equipped with a silvered, upholstered seating set, which in harmony with the wall covering was upholstered with yellow silk satin. Replaced at the time of Friedrich Wilhelm II by a yellow wallpaper with a floral border, it has now been restored again to the silk cover of the Rococo period.

The white panneling with carved ornamentation in the Silver-Plated Chamber (Room 353), evaded the destruction of 1943. The ceiling and the paintings above the doors have been reconstructed. The richly ornamented grandfather clock was presumably made by Hoppenhaupt the Elder in Potsdam ca. 1765.

In the gallery-like Library (Room 354), with its subtle green decorations and silver-plated ornaments, the six original cedar cupboards contain books from various palaces of Frederick the Great. Modern plaster casts of antique busts from the collections of Cardinal Polignac, acquired by the king in 1742, are standing on console tables. The carved and silver- plated console table belonged to the original furnishing.

The gilt ceiling stucco and the paintings, as well as the panelling and the leaves of the door in the Writing Room (Room 353), were completely reconstructed.

In the reconstruction of the King's Bedchamber (Room 356), which has been left without any interior décor, and in the adjacent First and Second Serv-

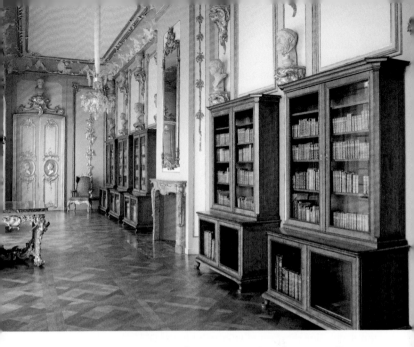

New Wing, First Apartment of Frederick the Great, Library

ants' Rooms (Room 357 and 358), outstanding art-works, including paintings, sculptures and furniture, from the time of Friedrich II and his successor are on display.

The tour continues in Room 229.

The official portraits, by Pesne and his workshop, of Frederick the Great's siblings and their spouses in the Blue Atlas Room (Room 229) were formerly hanging in the Berlin City Palace.

In the adjacent room (Room 228), the paintings and furnishings are reminders of the Berlin Monbijou Palace, which was used as a Hohenzollern museum from 1877 onwards, and after war-time destruction was dismantled from 1957 to 1960. The double-portrait by Pesne shows the two-year-old Friedrich II with

his favourite sister, Wilhelmine, later the Margravin of Brandenburg.

In the hallway (Room 230), the paintings of note-worthy events from the epoch of Frederick the Great testify to the development of "history painting of the fatherland" in Brandenburg-Prussia.

New Wing – Ground Floor

After his accession to the throne in 1797, King Friedrich Wilhelm III inhabited the western ground floor room (Rooms 309–317) in the New Wing under the rooms of his consort Luise. In the Vestibule (Room 123), renowned persons in Berlin society from the worlds of politics, art and science are shown in the foreground of Krüger's large-scale 1839 painting, *"Parade of the 1. Guard Foot Regiment in front of Friedrich Wilhelm III on Unter den Linden."*

The adjoining room still belongs to the Baroque representational rooms of Friedrich I in the Old Palace. Presumably meant to be the state bedchamber (Room 122) for his third wife, Sophie Luise von Mecklenburg-Schwerin, the room was used by Frederick the Great as a cabinet of antiquities. The original Baroque ceiling painting, richly ornamented with Baroque strap work and foliage, has survived in its original condition. The tapestries from the chinoise Grand Mogul series from Jean II. Barranband's Berlin Manufactory were made in the beginning of the eighteenth century.

The summer apartment of Friedrich Wilhelm II is visible from the Vestibule.

In 1788, Friedrich Wilhelm II had a **Summer Apartment** (Rooms 318–320) in the "Chinese-Etruscan" style constructed. After the structure was damaged

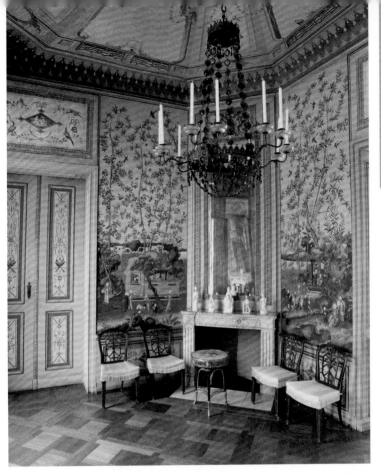

New Wing, Summer Apartment of Friedrich Wilhelm II, Dining Room

in the Second World War, three of the five rooms were restored.

In the Etruscan Room (Room 318), the ceiling was painted with antiquated vase decorations by Johann Gottfried Niedlich. The English coloured engravings of Johann Heinrich Füßli's illustrations of works by Shakespeare, along with the existing frames, were part of the original decoration.

45

In the Small Gallery (Room 319), where remnants of the original Chinese wallpaper still exist, the Italian decorative painter, Bartolomeo Verona designed the wall coverings, the window jambs and the ceiling mirrors. Multi-part sets of vases and two fish tanks supplement the furnishings in the last eighteenth century chinoiserie-style.

In the Dining Room (Room 320), Verona decorated the ceiling, the wood panelling, the door leaves and window jambs with geometricizing East-Asian motifs. The original wall covering, destroyed in the war, is replaced by a Chinese wallpaper that was made in 1820. The mulberry wood set of chairs, made about 1765/1770, belong to the original furnishings.

The tour continues in Room 309, the apartment of Friedrich Wilhelm III.

The Charlottenburg Apartment of Friedrich Wilhelm III (Rooms 309–317), originally designed for Queen Elisabeth Christine, were newly wall-papered and furnished with some pieces already existing in these rooms. Restored in a simplified version after destruction during the Second World War and painted in one colour, the rooms were supplied with furniture and artworks from the property of the king and his family. The landscape and history paintings with "Fatherland" motifs in the Antechamber (Room 309) testify to the value Friedrich Wilhelm III placed on the painting of his homeland. The large-scale paintings by Weitsch are reminders of the era's path-breaking journeys of discovery by Alexander Humboldt and Admiral Adam Johann von Krusenstern.

In the former Armory (Room 310), the paintings with mythological, religious and historical content, acquired by the king at Berlin Academy exhibitions, showcase the artistic development from Classicism

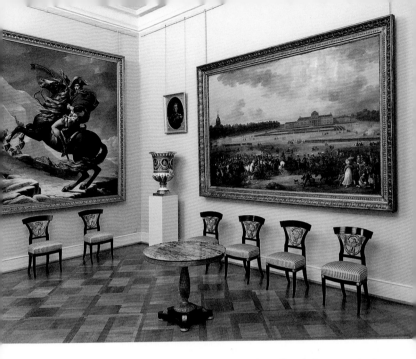

to Biedermeier genre painting. The mahogany desk originates from the study in the Berlin Royal Palace on Unter den Linden.

In the former library (Room 311), there is a display of outstanding paintings, including Karl Blechen's 1835 painting, View of the Villa d'Este, from the original inventory of the monarch's Charlottenburg apartments. The marble busts of Queen Luise and her oldest daughter, Charlotte, later to be consort to the Russian Tsar Nikolaus I, are the works of Rauch.

In the Yellow Room (Room 312), used by Friedrich Wilhelm III as a study, the decorative painting of the mirror frame is still preserved. Portraits, carried out in pastel tones, show the family members of the king, including the 1801 portrait of Luise by Elisabeth Vi-

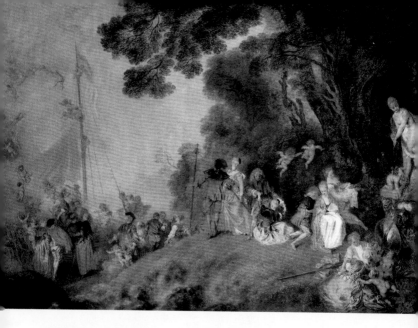

gée-Lebrun. The mahogany escritoire and birch wood chairs are part of the original furnishing.

In the Blue Room (Room 313), the former Japanese Room of Queen Elisabeth Christine, chinoiserie-style wall panelling of 1740/1742 painted by Friedrich Wilhelm Höder is still preserved. While in the Bedchamber (Room 314) officers' portraits and military themes are reminders of the Wars of Liberation against Emperor Napoleon I from 1812 to 1815, in the final antechamber (Room 317) outstanding French artworks are on display, including Jacques-Louis David's equestrian portrait, "Napoleon at the St. Bernhard Pass," created 1800/1801.

In the eastern rooms on the ground floor of the New Wing, "Masterworks from the Era of Frederick the Great" are on display (Room 332–344), starting by the end of 2019. French tapestries and prominent paintings, including Watteau's "Embarkation for

New Wing, Exhibition "Masterworks from the Era of Frederick the Great", Antoine Watteau's "The Embarkation for Cythera" from around 1718/1719

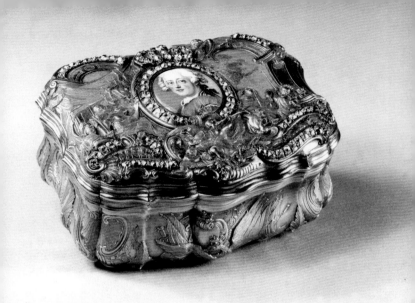

New Wing,
"Masterworks
from the Era of
Frederick the
Great", snuffbox
with enamel portrait
of Frederick the
Great, c. 1745

Cythera," exquisite furniture by Nahl and the broth-
ers Hoppenhaupt as well as gemmed snuffboxes are
among the highlights of artistic creation of the era of
Frederick the Great, documenting aspects of Prussian
court art in all of its multifaceted dimensions, as well
as the king's unique taste.

Visitor Service Schloss Charlottenburg
Spandauer Damm 10–22 · 14059 Berlin
Tel.: +49 (0) 30/32091-0 · Fax: + 49 (0) 30/32091-7400

Contact
Stiftung Preußische Schlösser und Gärten Berlin-Branden-
burg Besucherzentrum (Visitor Centre) an der Historischen
Mühle

Information
An der Orangerie 1 · 14469 Potsdam
Tel.: +49 (0) 331.9694-200 · Fax: +49 (0) 331.9694-107
E-Mail: info@spsg.de

Opening Times and Admission
Up-to-date opening times, entrance fees and information about
special exhibits can be found at www.spsg.de/en/home/

Group Reservations
Tel.: +49 (0) 331.9694-200
E-Mail: besucherzentrum@spsg.de
The visitor centre is happy to provide information about group
rates, guided tours and personal arrangements.

Getting There
by car, via A100, take the Spandauer Damm exit
(limited paid parking)
by bus, take bus line
M45 (Luisenplatz/ Schloss Charlottenburg),
bus line 109 (Luisenplatz/Charlottenburg), or
bus line 309 (Schloss Charlottenburg)
by S-Bahn, take S 41/42 (Westend)
by subway, take U7 (Richard-Wagner-Platz, then transfer to
bus line M45)
or take U2 (Sophie-Charlotte-Platz + 15 min. walk)

Tips for Visitors with Handicaps
The palace is wheelchair accessible; disabled toilets are
available. Special touch and verbal imaging tours offer an
opport unity for blind or visually impaired visitors to com-
prehend the building and artworks, and thus experience the
eighteenth century. Special programs available upon request.

 For further information: handicap@spsg.de

Museum Shops
The museum shops of the Prussian Palaces and Gardens in-
vite you to discover the world of the Prussian kings and queen

– and to take your experience home with you. At the same time, your purchase will have the double advantage of being a donation, since the proceeds of the Museumsshop Ltd go to supporting the acquisition of artworks and the restoration work in the palaces and gardens of the foundation.

The Museumsshops, with a wide array of items, are to be found in Berlin, e. g. in various parts of Charlottenburg Palace and in Schönhausen Palace:

www.museumsshop-im-schloss.de

Cooperation

Berliner Residenz Konzerte
Orangery Berlin GmbH
www.residenzkonzerte.berlin/english/home.html
www.orangerie-charlottenburg.com/en/
Große Orangerie Schloss Charlottenburg
Spandauer Damm 22–24 · 14059 Berlin
E-Mail: tickets@residenzkonzerte.berlin

Dining

Restaurant and Café "Kleine Orangerie"
Tel.: +49 (0) 30.3222021

Tourist Information

Berlin Tourismus Marketing GmbH
Am Karlsbad 11 · 10785 Berlin
www.visitBerlin.de/en
Information@visitBerlin.de
Tel.: +49 (0) 30.264748-0
Hotline call centre +49 (0) 30.250025

For further viewing we recommend the Grunewald Hunting Palace. This oldest Hohenzollern Palace in Berlin was built in 1542 in Renaissance style for the Brandenburg elector, Joachim II and served numerous members of the Prussian royal family as a hunting lodge. In use as a museum since 1932, the palace houses a comprehensive painting collection, including outstanding works by Lucas Cranach.

Also worth seeing is Schönhausen Palace, in Berlin-Pankow, which served as the summer residence for Frederick the Great's wife, Elisabeth Christine. The apartments on the ground floor are devoted to the life of the queen, while the displays on the upper floors present the history of the palace in the twentieth century. Schönhausen was used as the seat of the first president of the GDR and later as a GDR-government guesthouse for visitors of state.

Literature

Margarete Kühn: Die Bau- und Kunstdenkmäler von Berlin – Schloss Charlottenburg, 2 vols., Berlin 1970.

Exhibition catalogue: Sophie Charlotte und ihr Schloss. Ein Musenhof des Barock in Brandenburg-Preußen, ed. Stiftung Preußische Schlösser und Gärten Berlin-Brandenburg. Exhibition, Berlin, Schloss Charlottenburg, Berlin 1999/2000. Munich/London/New York 1999.

Hans Joachim Giersberg/Rudolf G. Scharmann: 300 Jahre Schloss Charlottenburg. Texte und Bilder, ed. Stiftung Preußische Schlösser und Gärten Berlin-Brandenburg, Potsdam 1999.

Schloss Charlottenburg. Amtlicher Führer, ed. Stiftung Preußische Schlösser und Gärten Berlin-Brandenburg, 9th revised version, Potsdam 2002.

Rudolf G. Scharmann: Schloss Charlottenburg, ed. Stiftung Preußi-sche Schlösser und Gärten Berlin-Brandenburg, 2nd revised and supplemented version, Potsdam 2006.

Schloss Charlottenburg in Berlin. Im Wandel denkmalpflegerischer Auffassungen, Jahrbuch Stiftung Preußische Schlösser und Gärten Berlin-Brandenburg, vol. 7, 2005, Berlin 2007.

Kronschatz und Silberkammer der Hohenzollern, ed. Stiftung Preußische Schlösser und Gärten Berlin-Brandenburg, Berlin 2010.

Acknowledgments

Published by the Stiftung Preußische Schlösser und Gärten Berlin-Brandenburg

Text: Rudolf G. Scharmann (Palace and Garden Buildings)
Monika Theresia Deißler (Garden)
Translation: Catherine Framm, Julia Schmidt-Pirro
Editing: David Fesser, Deutscher Kunstverlag
Design: M&S Hawemann
Layout: Hendrik Bäßler, Berlin
Production: David Fesser, Deutscher Kunstverlag
Coordination: Elvira Kühn
Printing: DZA Druckerei zu Altenburg GmbH, Altenburg
Photography: Bildarchiv SPSG/Photographs: Hans Bach, Roland Handrick, Andreas Jacobs, Gerhard Klein, Alexander Lechtape, Daniel Lindner, Wolfgang Pfauder, Leo Seidel

The Deutsche Nationalbibliothek lists this publication in the Deutsche Nationalbibliografie; detailed bibliographical data are available on http://dnb.d-nb.de